THE ART OF

PLANTS VS. ZOMBIES

A Visual ~~Retra~~ ~~Retropsec~~ Book

The zombies would like to thank George Fan, Rich Werner, Jeremy Vanhoozer, Mark Barrett, Monte Michaelis, David Ryan Paul, Augie Pagan, Cory Allemeier, Taylor Krahenbuhl, Dev Madan, Kong Lu, Sarah Dicken, Matt Holmberg, Caroline Ancessi, Shaun Hayes, Holgate, Charles Guan, Clint Jorgenson, Justin Wiebe, Gordon Wang, Mihai Anghelescu, and everyone who worked on the games represented in this visual ~~retra retropses~~ book.

▶ Very few humans were harmed in the making of this book.

THE ART OF

A Visual ~~Retra Retropsec~~ Book

Cover Art by **RICH WERNER**

DARK HORSE BOOKS

MIKE RICHARDSON President and Publisher NEIL HANKERSON Executive
Vice President TOM WEDDLE Chief Financial Officer RANDY STRADLEY Vice
President of Publishing MICHAEL MARTENS Vice President of Book Trade Sales
ANITA NELSON Vice President of Business Affairs SCOTT ALLIE Editor in
Chief MATT PARKINSON Vice President of Marketing DAVID SCROGGY
Vice President of Product Development DALE LaFOUNTAIN Vice
President of Information Technology DARLENE VOGEL Senior Director
of Print, Design, and Production KEN LIZZI General Counsel DAVEY
ESTRADA Editorial Director CHRIS WARNER Senior Books Editor
DIANA SCHUTZ Executive Editor CARY GRAZZINI Director of Print
and Development LIA RIBACCHI Art Director CARA NIECE Director
of Scheduling TIM WIESCH Director of International Licensing
MARK BERNARDI Director of Digital Publishing

Publisher **MIKE RICHARDSON**
Editor **PHILIP R. SIMON**
Assistant Editor **EVERETT PATTERSON**
Designer **KAT LARSON**
Digital Production **CHRISTINA McKENZIE**

Dark Horse thanks LEIGH BEACH, SHANA DOERR, AMY HEVRON, JULIE JENKINS,
A.J. RATHBUN, PHILIP SMITH, BRENNAN TOWNLEY, JEREMY VANHOOZER, and
everyone at PopCap Games.

▶ Printed with ink from Jeremy's tears.

Published by Dark Horse Books, a division of
Dark Horse Comics, Inc., 10956 SE Main Street,
Milwaukie, OR 97222

International Licensing: (503) 905-2377
To find a comics shop in your area, call the Comic
Shop Locator Service toll-free at 1-888-266-4226.

First edition: May 2014 | ISBN 978-1-61655-331-9

10 9 8 7 6 5 4 3 2 1
Printed in China

All text and images assembled by the zombies
at PopCap Games, unless otherwise indicated.

DARKHORSE.COM I POPCAP.COM

THE ART OF PLANTS VS. ZOMBIES

Peepulz...always feeling the need to "name-drop"...

PLANTS vs. ZOMBIES

THE BEGINNINGING

Zombies like ~~nostu nastol~~ looking at old picturs, because we
look good always. Want proof? Turn page, then next page.
Even zombie made by pencil look pretty, even side-by-side
alongside old stinky plants. C'mon, looksee.

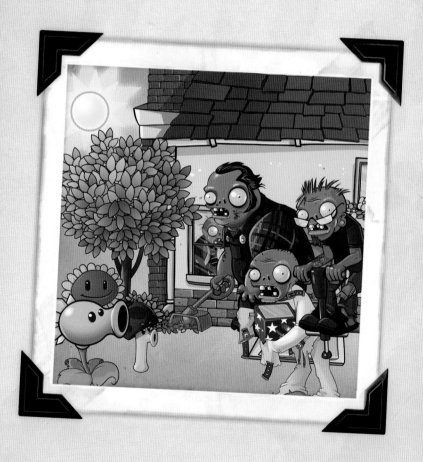

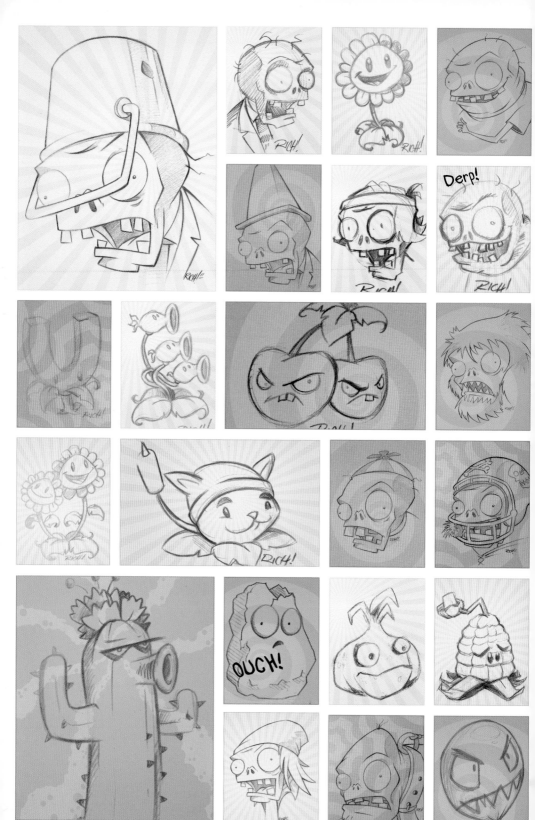

~~SKECH~~ DRAWRINGS BY RICH WERNER. WE ATE HIS BRAINZ.

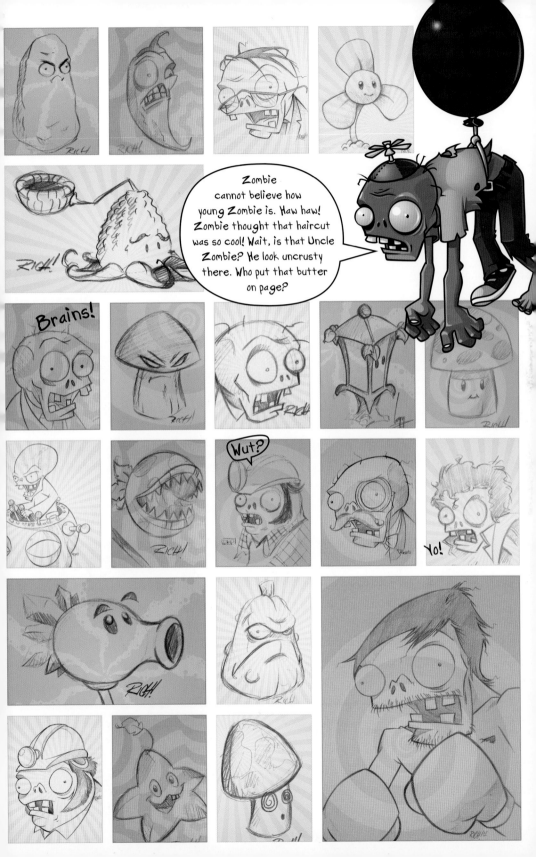

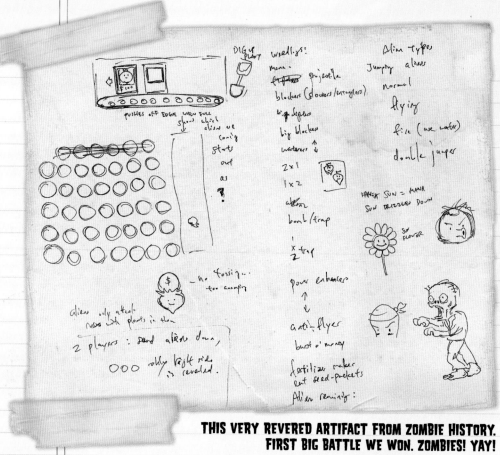

THIS VERY REVERED ARTIFACT FROM ZOMBIE HISTORY. FIRST BIG BATTLE WE WON. ZOMBIES! YAY!

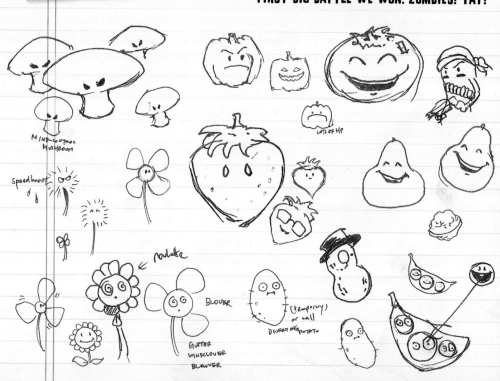

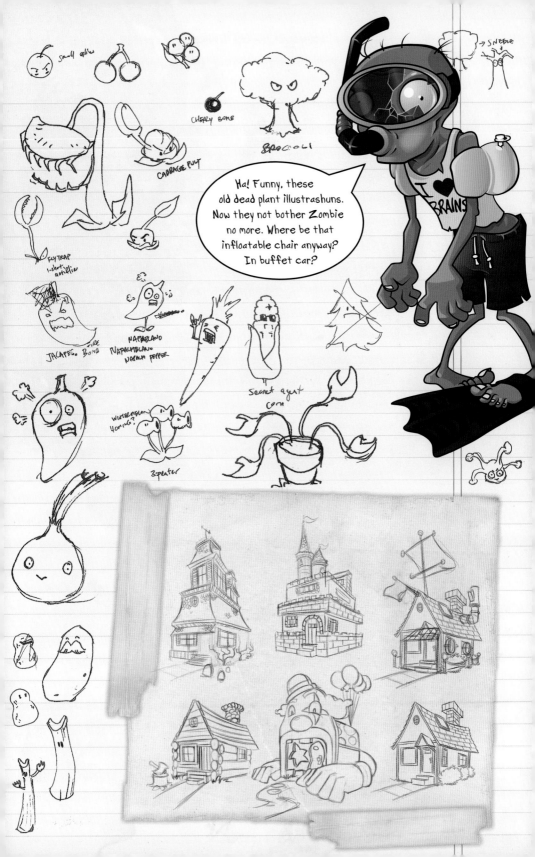

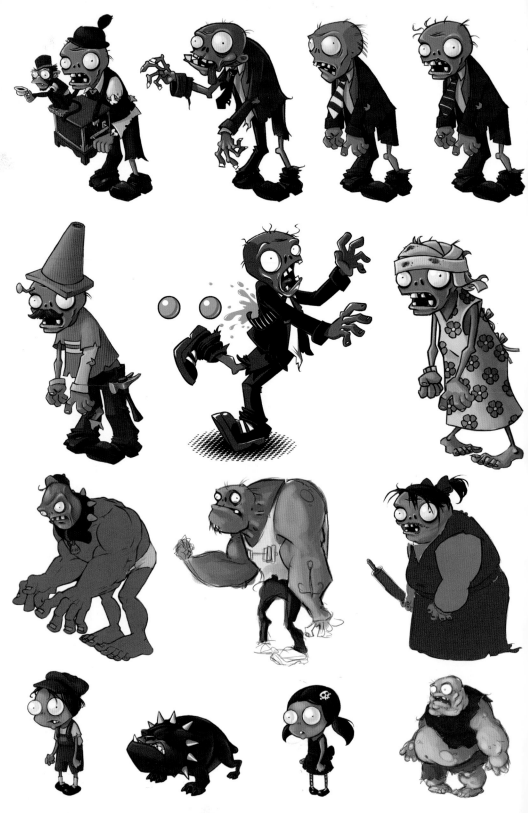

ONE OF THESE OLD CONCEPTS CALLED SELF "THE TANGLER"...GUESS WHICH ONE.

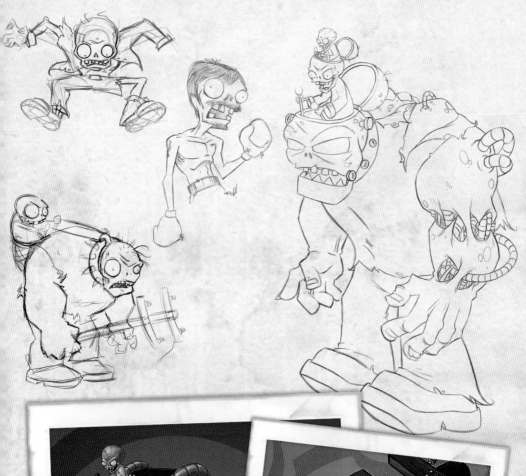

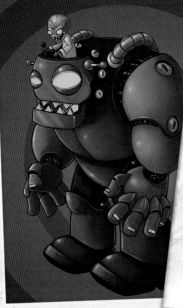

Oh, this was wild zombie weekend. Too much pleather pants. Boom!

Hey, Zomboss! What ever happen to that guy?

REJECTED TITLE IDEAS . . .

GAME SHOULDA BEEN "ZOMBIES ARE AWSUM!"
NO ONE ASK ZOMBIES AT TIME. SO ENDED UP
SOMEBODY CHOOSE "PLANTS VS. ZOMBIES" FIRST
AND LAST. DUM.

Zombiegeddon?

Zom-Botany

Bloom & Doom

Flower Garden vs.
The Unholy Zombie Apocalypse

Keep Off the Grass!
[Or Die!]

Dead Man Mowing
Lawn of the Dead

Peas Stop the Zombies!

Cul-de-sac of the Living Dead
Suburb of the Living Dead

Weed Eaters

~~Zomburbia~~

~~Zombies vs. Plants~~

Zombie Leafeaters!

Shamblefest
Lawnarchy
Lawnslaught
Mowtilation
Mowtown Mowdown
Plant or Perish

Seizure Salad
~~Day of the Daffodil~~
~~Gazebo of the Damned~~
~~The Bury Patch~~

~~Can I Borrow a Cup of Brains?~~

~~Dial Z for Zombie~~

Keeping Alive with the Joneses
Hey, That's Not Organic!

Field of
Screams

A Crop Eclipse Now

The Vegetarian Dead:
"Beeaaannnnsssss!"

Creepy Ghouls and Gardening Tools:
Attack of the ~~Vegan~~ Zombies!

Hey You Zombies, Get Off My Lawn!
The Attack of the Tomato Killers

Ghouls in the Grass
Photosynthesize or Die

Plot in Hell
Post-Humus
Gardening

28 Shrubs Later

Beanstalkers

Zombies ~~Ate My Garden~~

Horticultural
Horror

~~Gruesome~~
~~Garden~~

Rest in Peas?
Piece Corpse
Plantocalypse

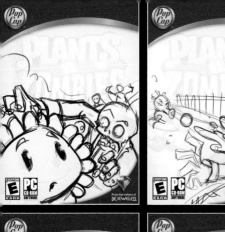
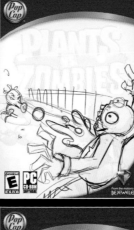
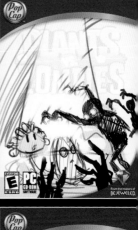
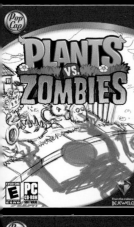
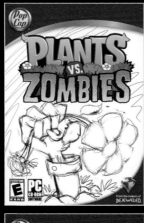
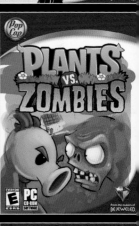
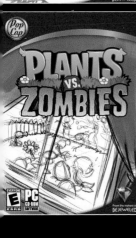
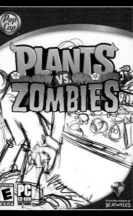

COVER CONCEPTS

EARLY COVUR OPTIONS NOT HAVE ONE THING MUST HAVE TO BE PERFECT COVER THINGY. THAT IS: ONLY ZOMBIE. TOO MANY PLANTS EQUAL NO ONE BUYING GAME TO PLAY CAUSE NOT ENOUGH ZOMBIE ON COVER. ONLY ZOMBIE BE THE HIT HIT HIT

CRAZY DAVE

Hey there, neighbor. This is a letter to you from me, Crazy Dave. But you can call me Crazy Dave. Remember that time we stopped the zombies from wrecking the neighborhood? I remember like it was yesterday. Hm? It was yesterday? I've been around since the early days of this botanical battle. I've been featured three times in *Beard-Lover's Monthly*. I'm in the current issue. You should read it. I've always loved plants, since I was a baby and got a sunflower for my birthday along with a pancake, a bottle cap, a vintage copy of *Lawnmageddon*, a puppy, six bolts, a screwdriver, and some copper wire. I made a me and never saw that thing again. No, I like plants and plants and puppies(they show up later) than anyone. Oh, and zombies. I learned that early. We'll talk sooner than you think. Where's that platypus at anyway?

—Crazy Dave

Why you wanna look here?

Nothing to see but old timey old stuff.

Only put in book by akcident. Stoopid glue.

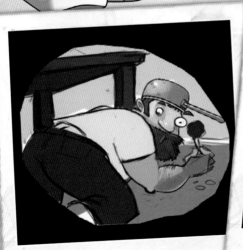

This funny. Zombie remember that fight. We won.

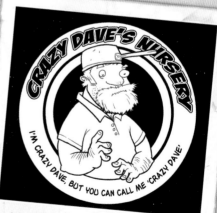

Eh, Zombie not see it. Just man with pot on head. Whoopsiedodah.

TALKIN' ABOUT THE GOOD OLD DAYZ

Sometimes zombies get together for nice zombie family portrait and then ugly plantz come by and try to ruin it. Why plants hafta be like that? Anyway, here are some nice pitchers of zombies through the ages. Also some pitchers of plantz (what have always been jerks) becuz zombies not good at photo editing software.

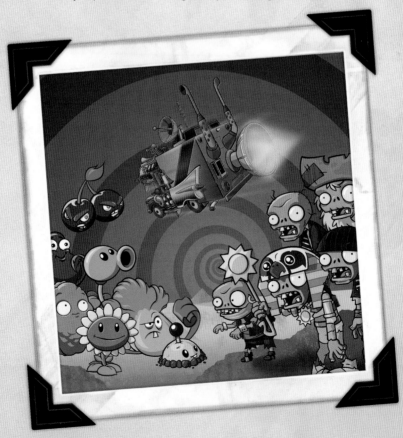

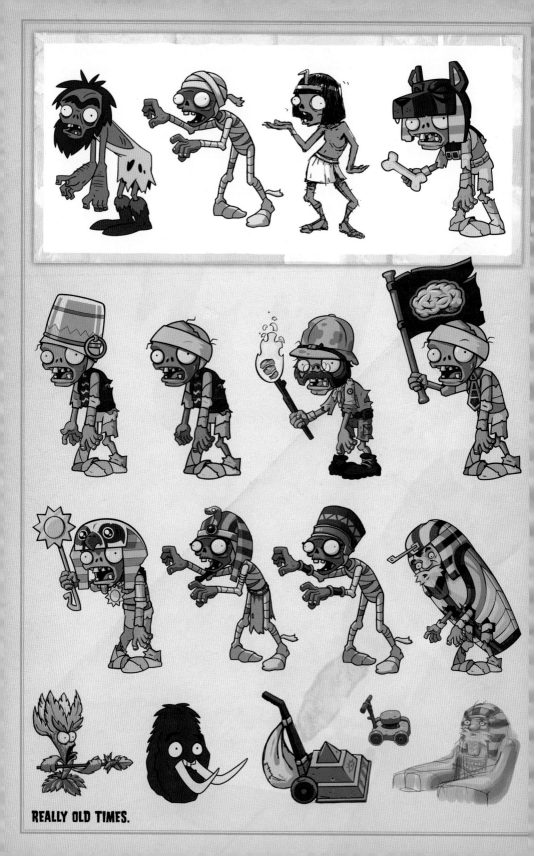

REALLY OLD TIMES.

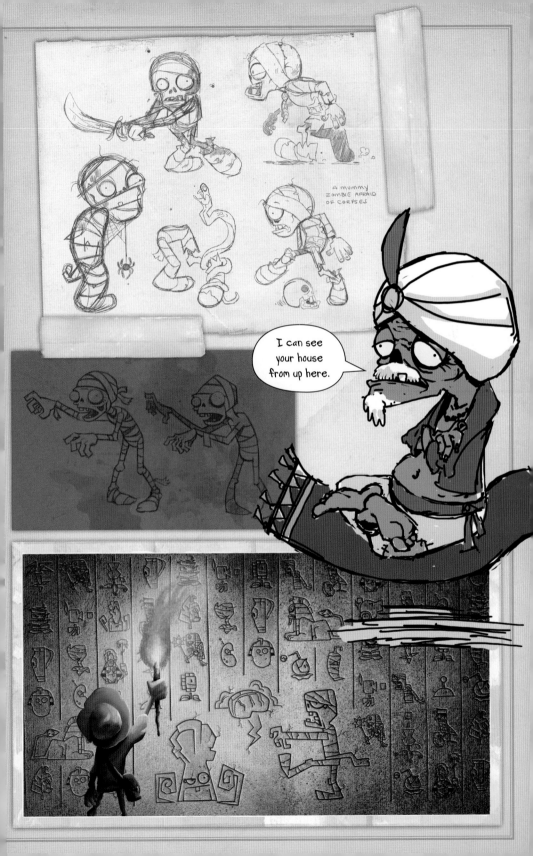

A mummy zombie afraid of corpses

I can see your house from up here.

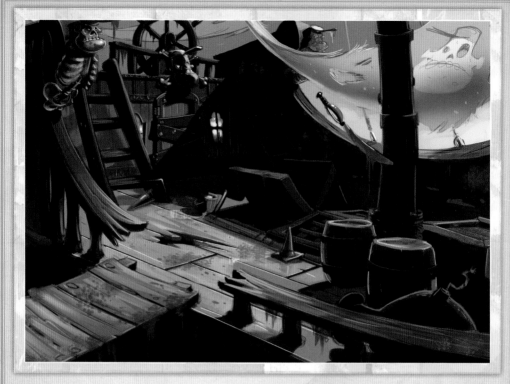

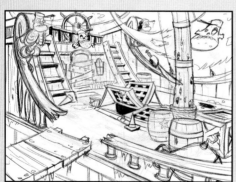

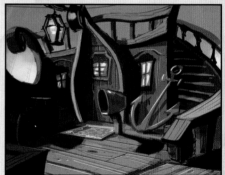

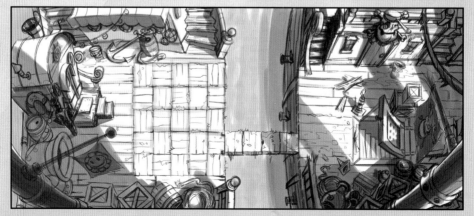

SWASB SWSH PIRATE ZOMBIES LOVE SWABBING DECK...WITH PLANTS!

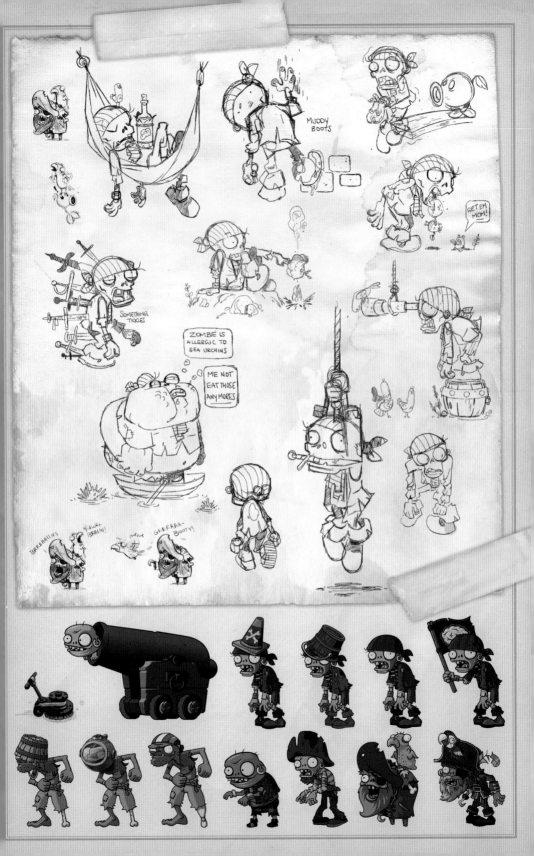

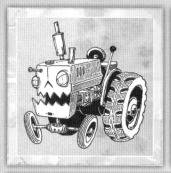
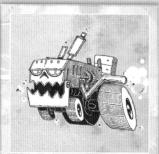
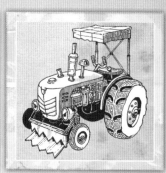

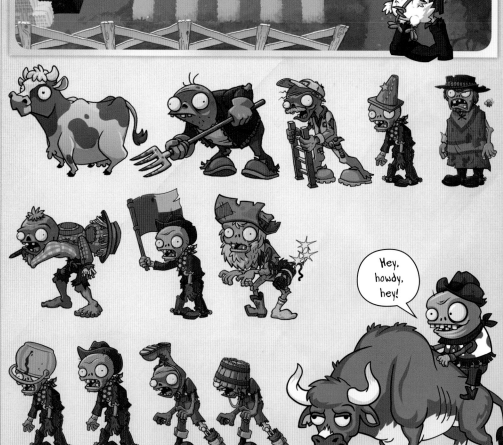

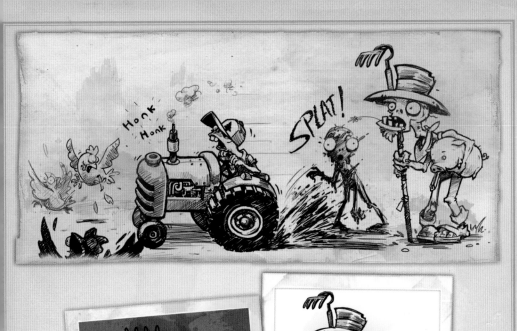

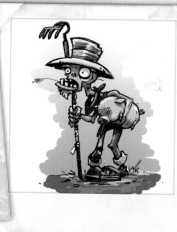

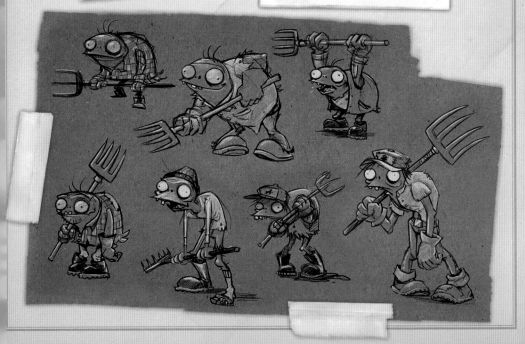

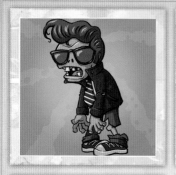
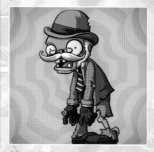
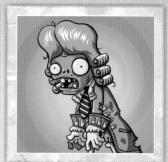
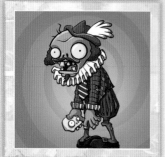
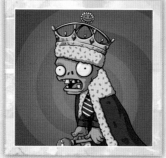
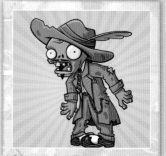

ZOMBIES AGE REALLY GOOD.

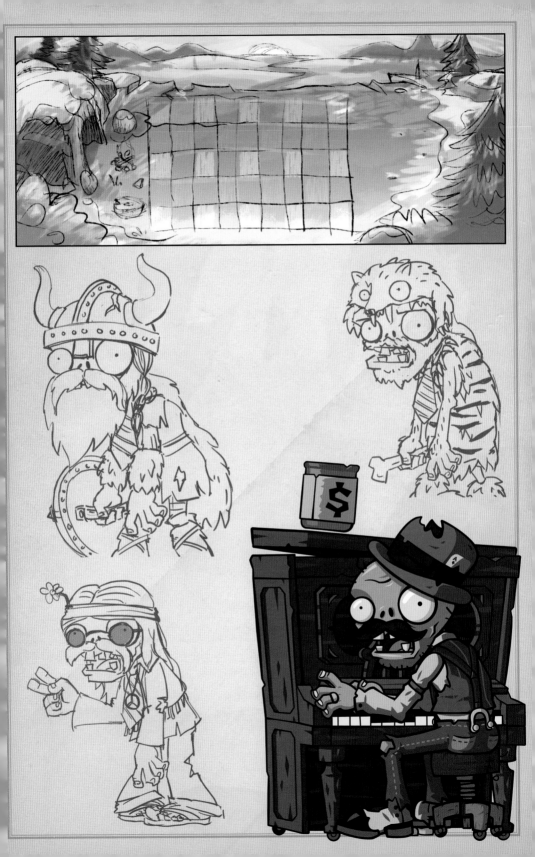

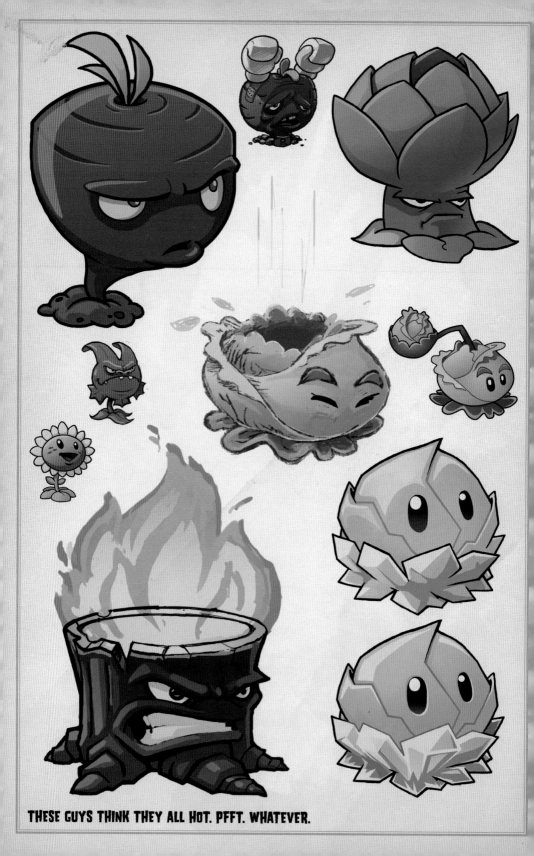

THESE GUYS THINK THEY ALL HOT. PFFT. WHATEVER.

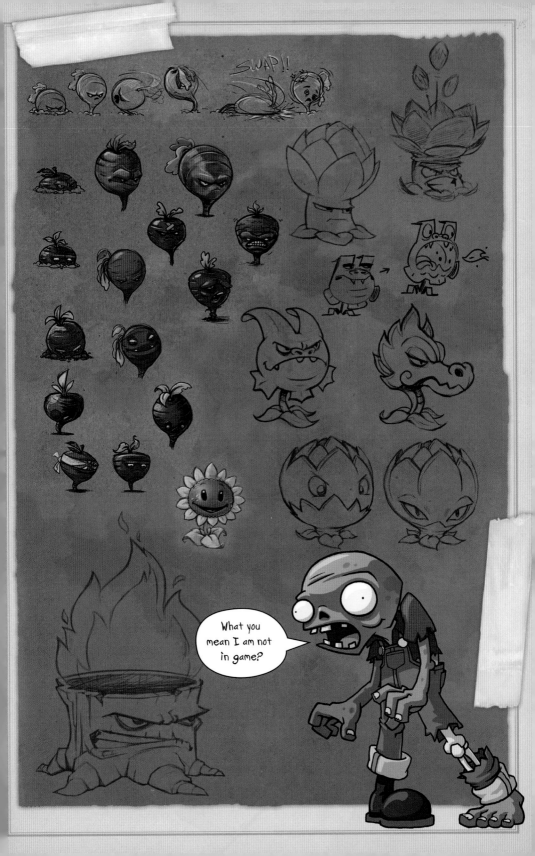

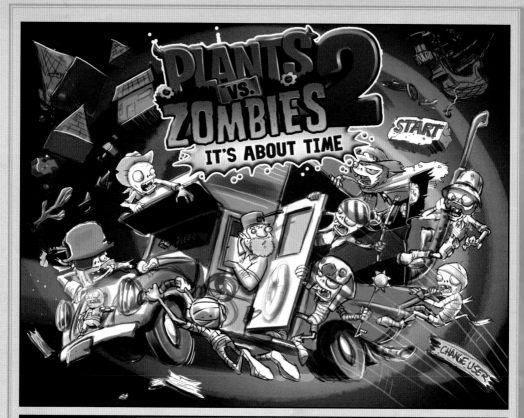

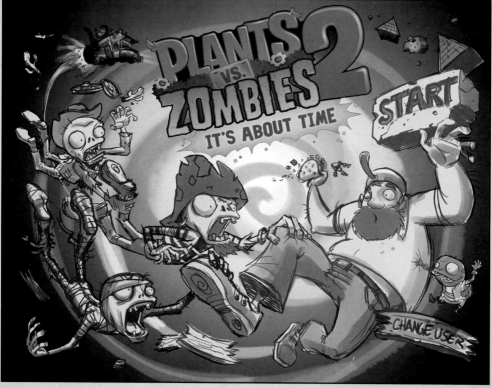

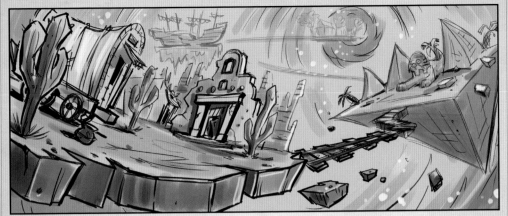

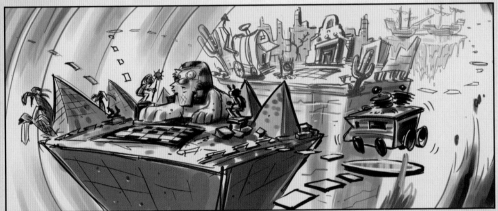

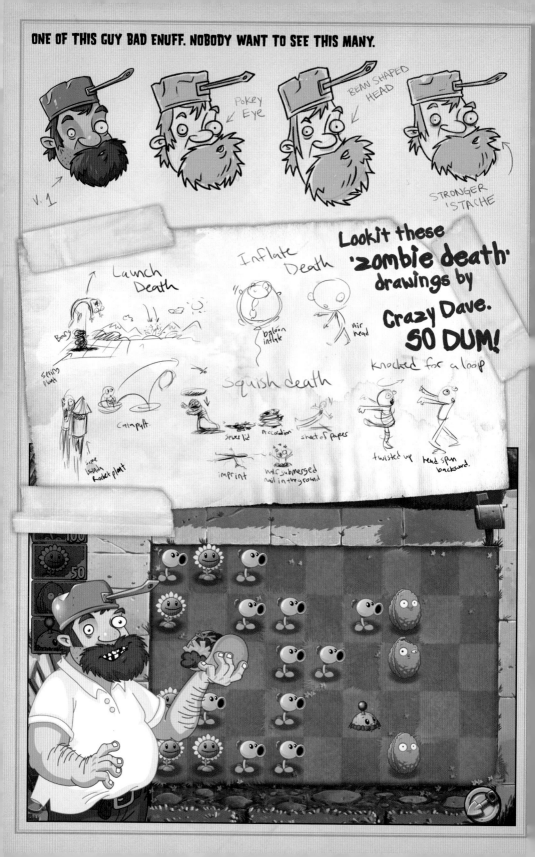

ROADSIDE DISTRACTIONS

Nobody think we go on vacashun. They think: brains, brains, brains. But not realize: good brains everywhere. So we go around to there. We wish you were here. Zombies already are. Where the grass is always ~~groe gren greenar~~ worth stomping on.

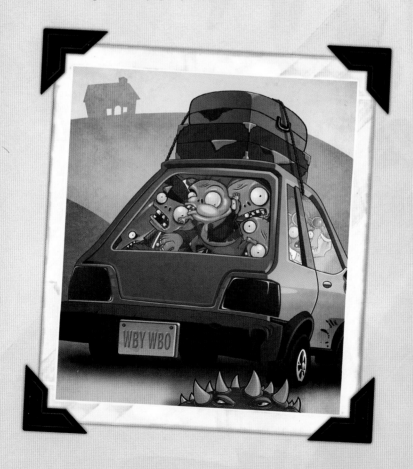

![Plants vs. Zombies Adventures](promotional map poster)

PLANTS VS. ZOMBIES
Adventures

Welcome
POPULATION 132 ZOMBIE

The Boonies

Cadaver Cavern

CAUTION
HARD HAT
AREA

Visit Matilda's
Plantagen
Just Ahead

DETOUR

**BIG
ZOMBIE COUNTRY**

- Unearth more plants, more zombies, and new characters.
- Send zombie invasions to your friends' towns.
- Zombies are off the grid... they're coming from every direction!
- Make zombies part of your social life.

**LIVE, GROW AND ZAP ZOMBIES.
IT'S ALL HERE IN BIG ZOMBIE COUNTRY!**

SLOW
ZOMBIES
AT PLAY

Send
Zombies to
Friends

PopCap

Dire Spires

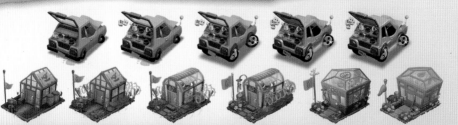

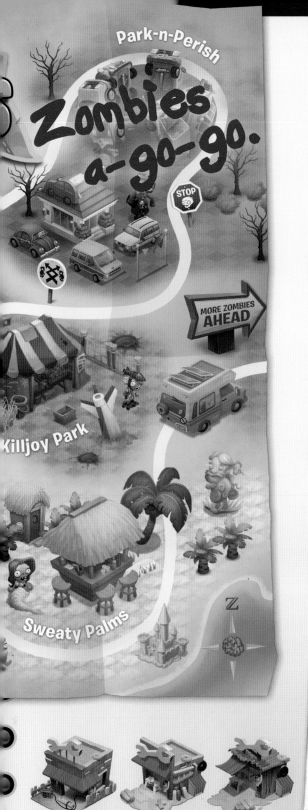

Park-n-Perish

Zombies a-go-go.

STOP

MORE ZOMBIES AHEAD

Killjoy Park

Sweaty Palms

Z

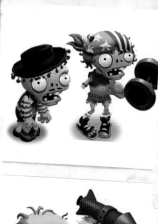

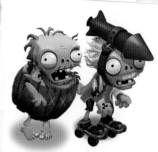

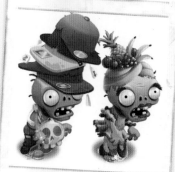

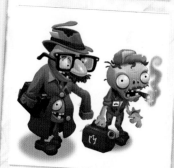

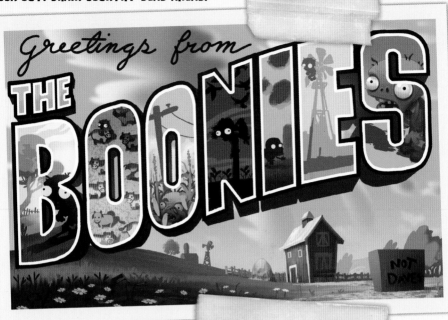

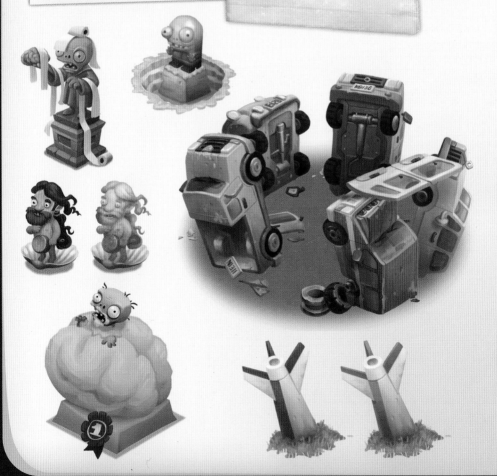

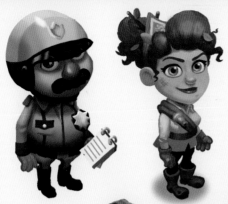

CAUTION
HARD HAT
AREA

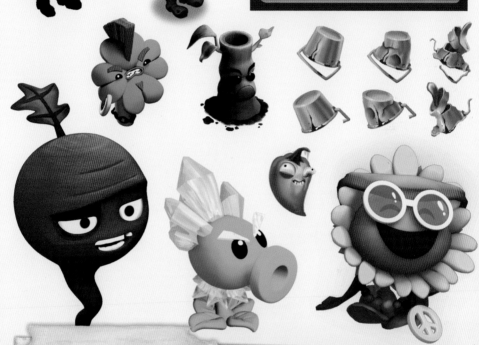

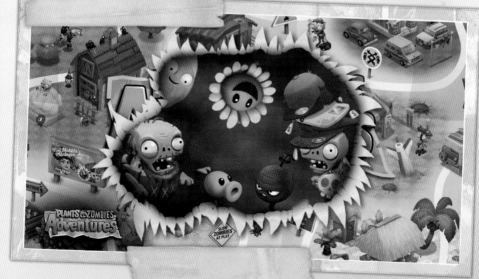

PLANTS & ZOMBIES Adventures

CLUB ZOMBIES AT PLAY

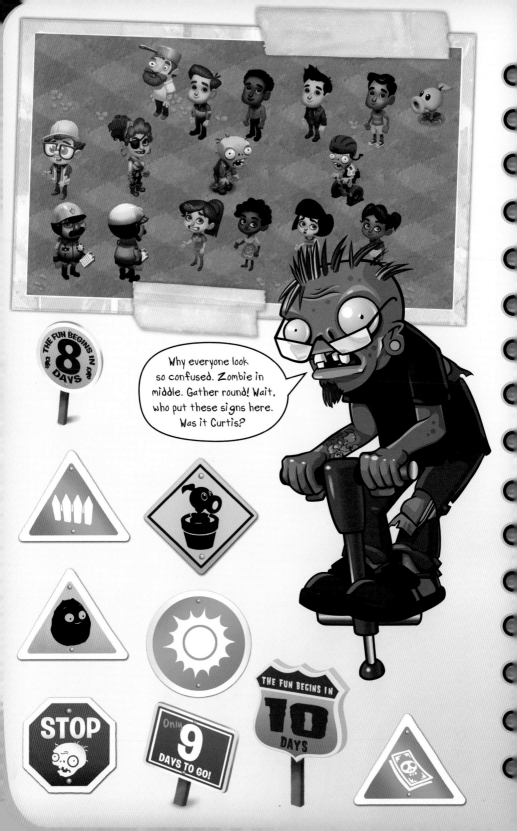

PLANTS vs. ZOMBIES
GARDEN WARFARE

WE JOIN THE ~~ARMY AIR FORCE~~ ~~NAVY MARINES~~ ZOMBOSS

It time to talk of brave zombies who come together to knock out evil Plant Hun who wanna take world over. It evil time peepul. But we join up together and be strong. Fancy ~~technol teknow~~ weapons from big boss help, too.

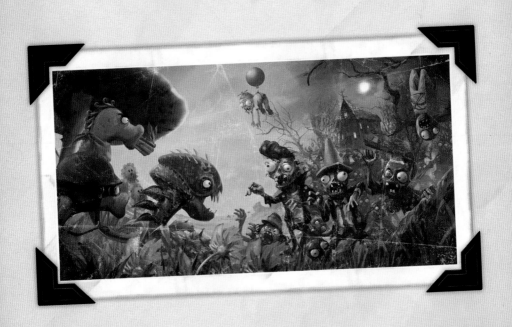

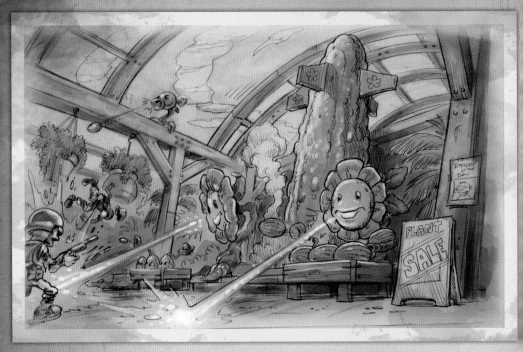

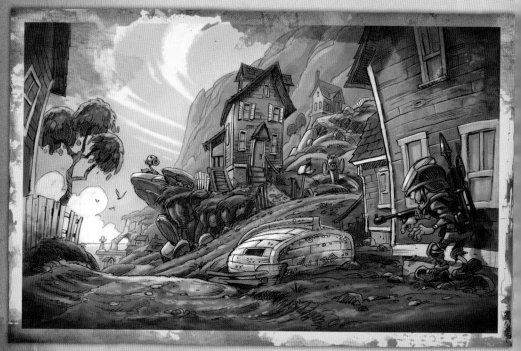

CHECK OUT PRETTY UNIFERMS. THEY PUT THE LIME IN THE COCONUT FOR SURE.

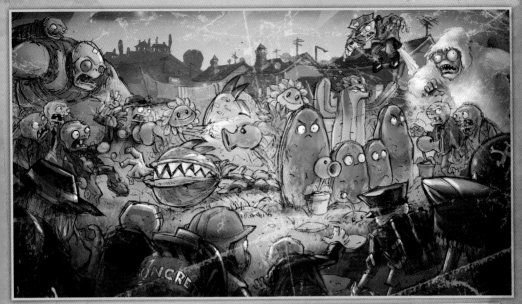

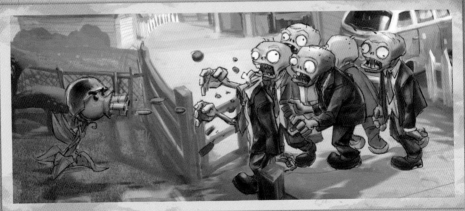

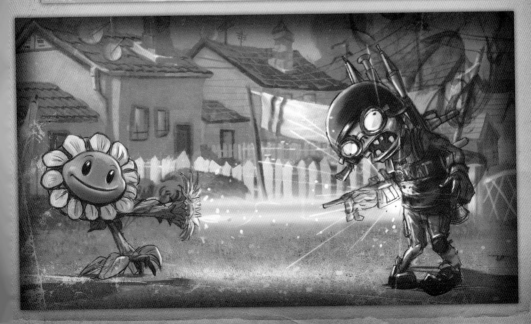

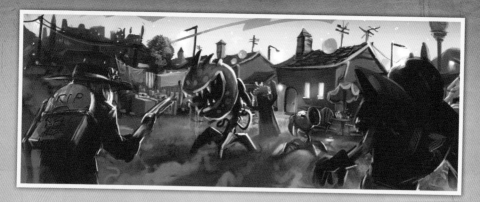

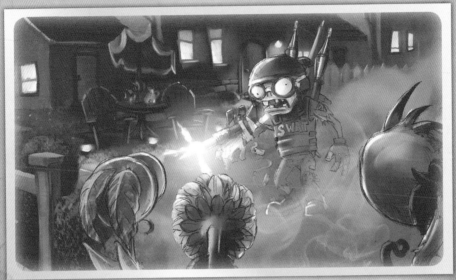

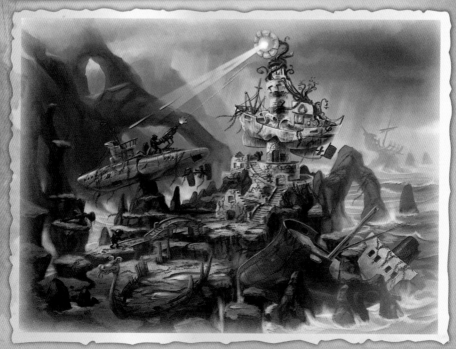

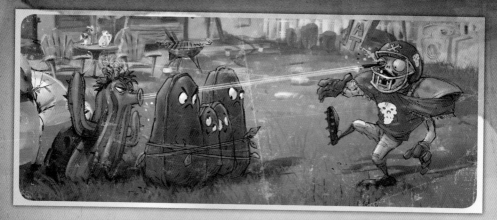

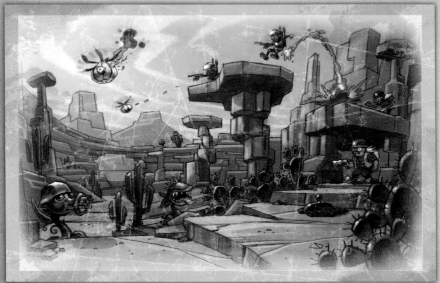

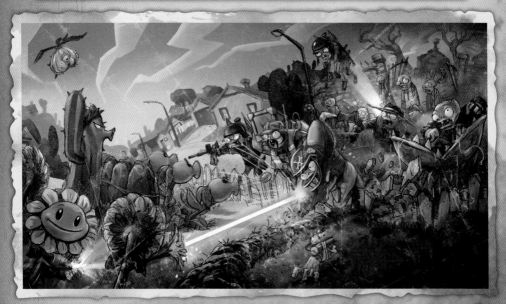

GOT 99 PROBLEMS. BUT A PLANT AIN'T ONE. FIGHT THE PLANT INFUSTASHUN!

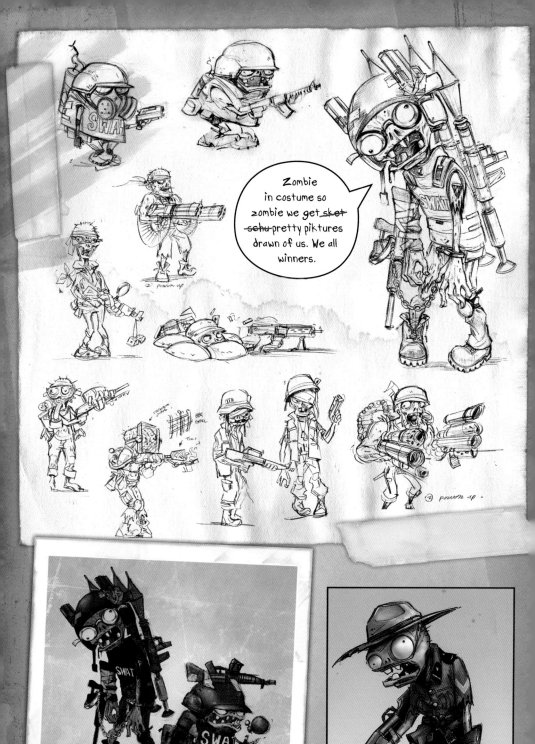

THESE HANSUM SOLDIERS SHOP AT MALL OF DUTY.

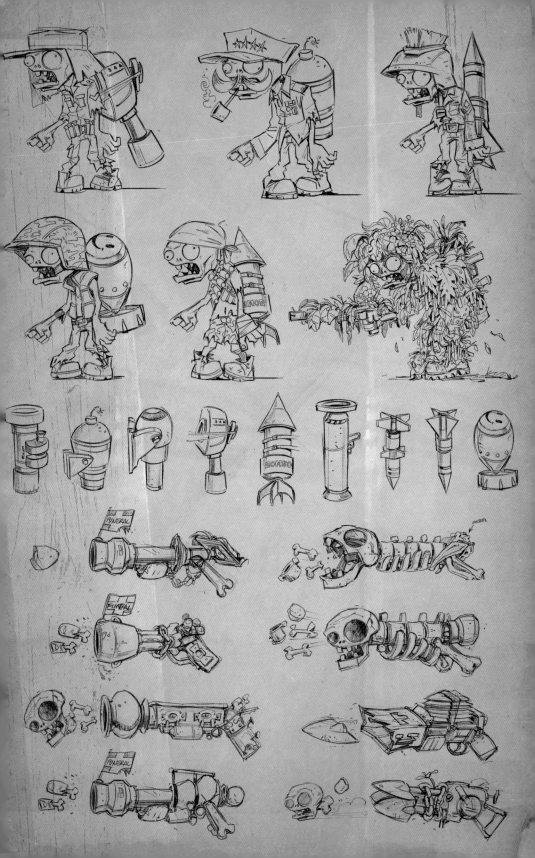

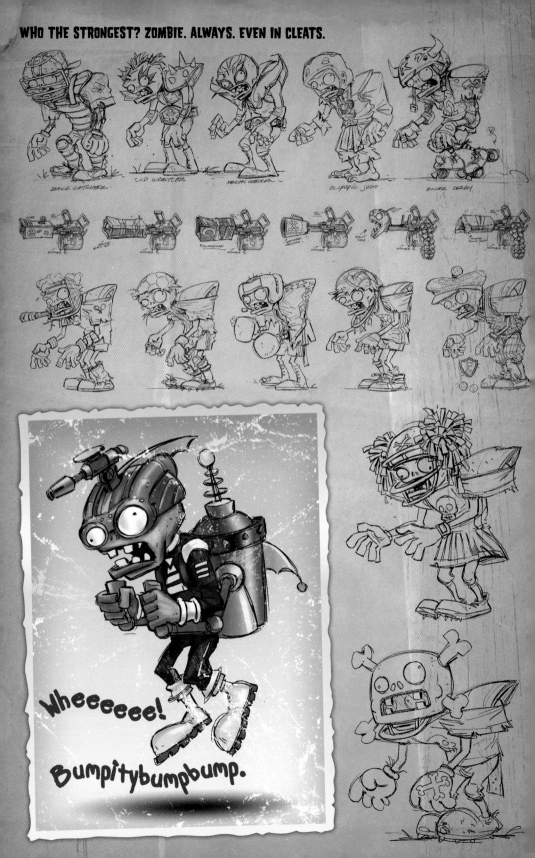

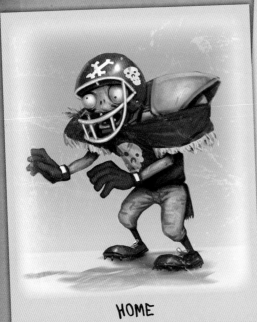

HOME

VISITOR

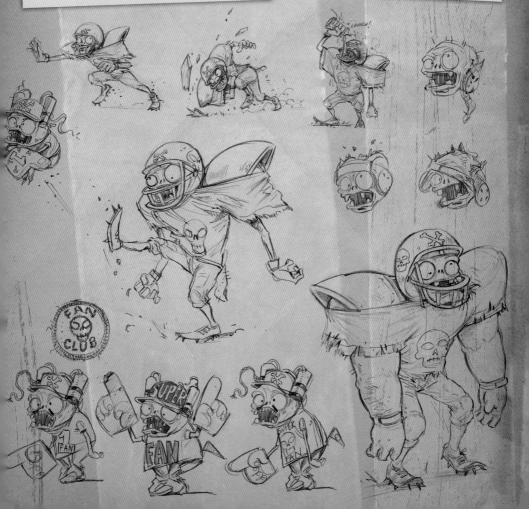

THIS HOW ZOMBIE INVENT STUFF.

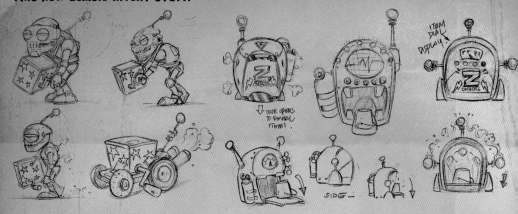

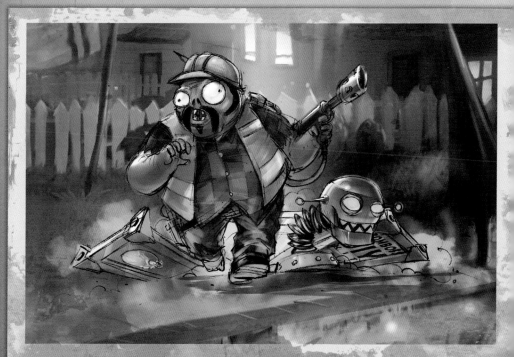

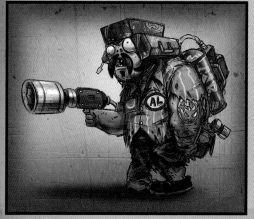

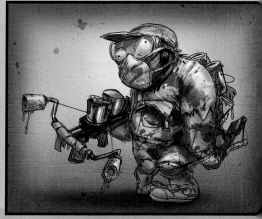

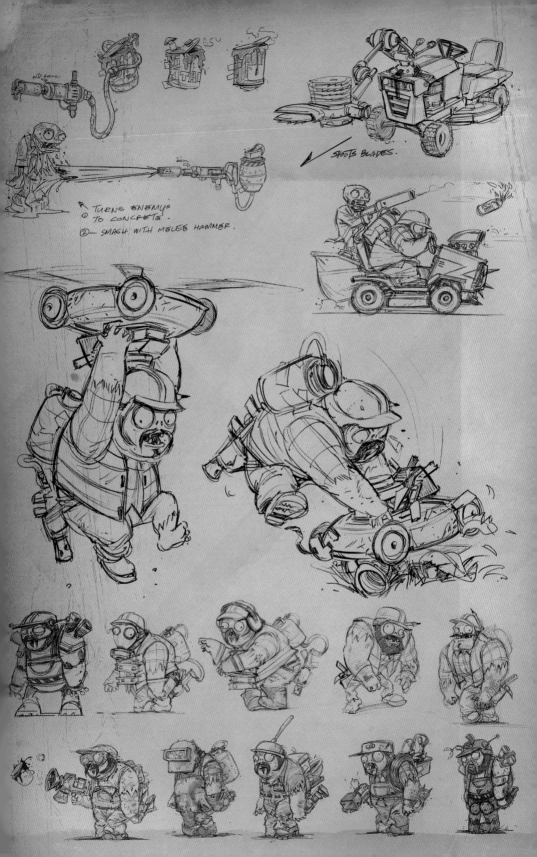

SHOOTS BLADES.

TURNS ENEMYS
TO CONCRETE.
SMASH WITH MELEE HAMMER.

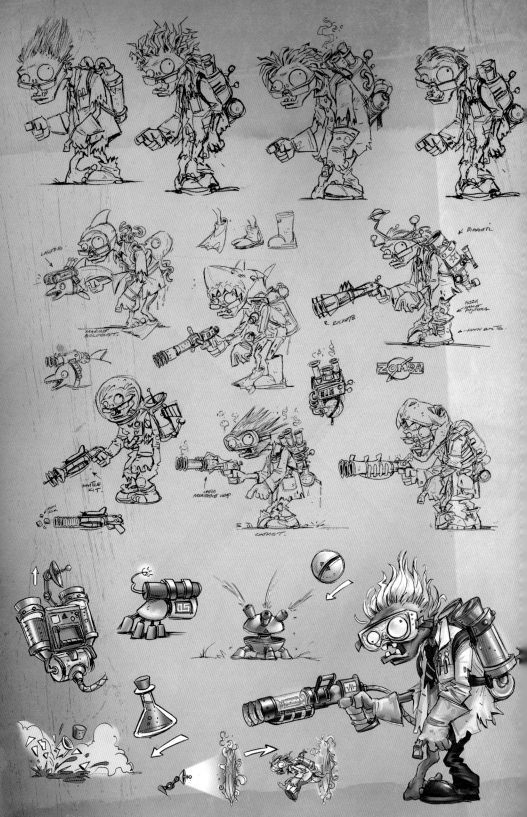

HAH, ZOMBIE THINK BACK TO TIME UNCLE PHILLY LOST PANTS. AND THESE HAIRCUTS.

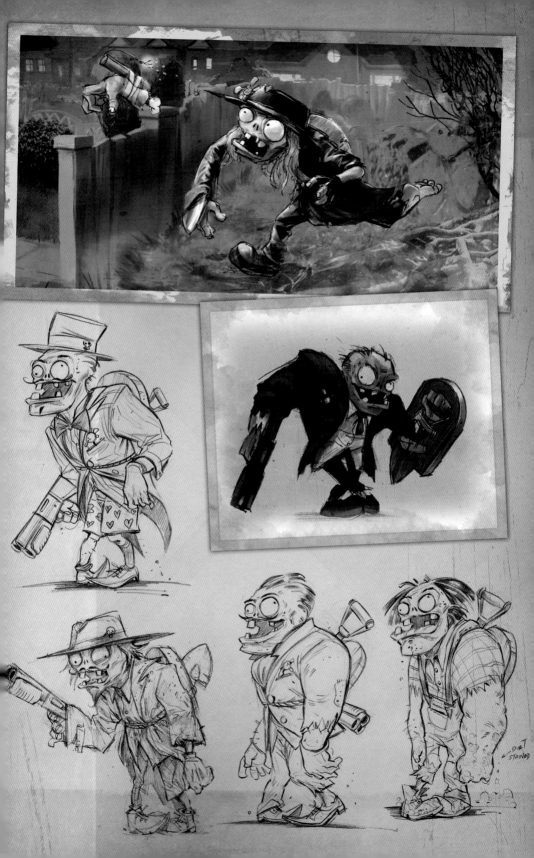

DIRT
STAINED

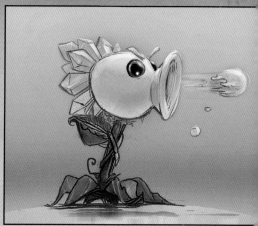

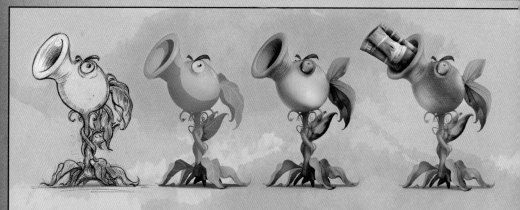

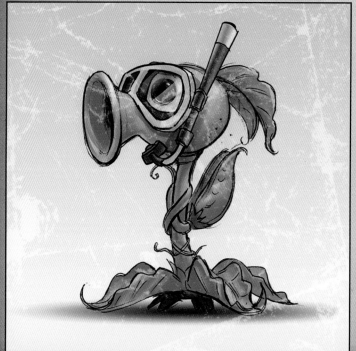

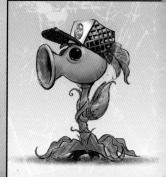

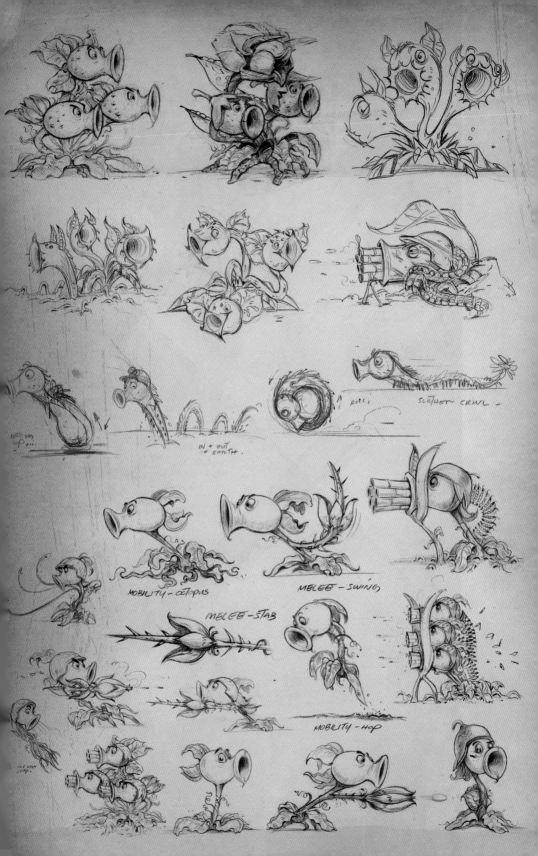

MOBILITY - OCTOPUS

MELEE - SWING

MELEE - STAB

MOBILITY - HOP

IN + OUT
OF EARTH.

ROLL

SLITHER CRAWL

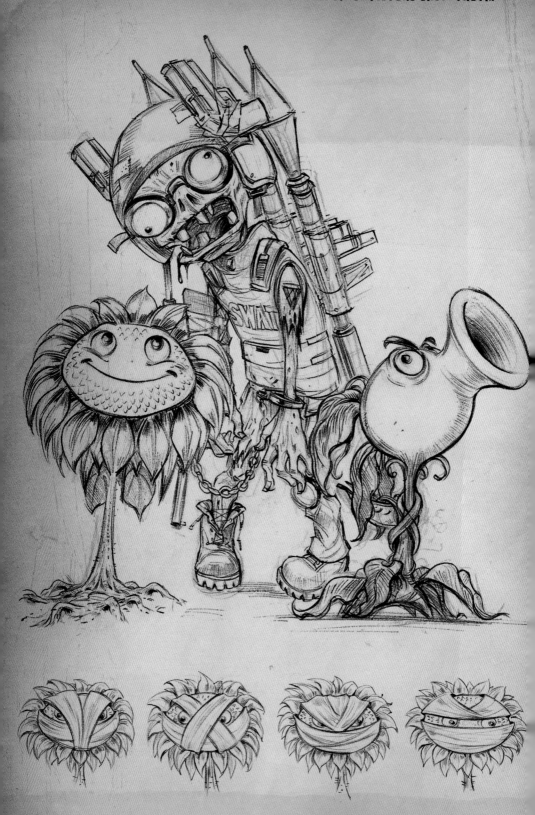

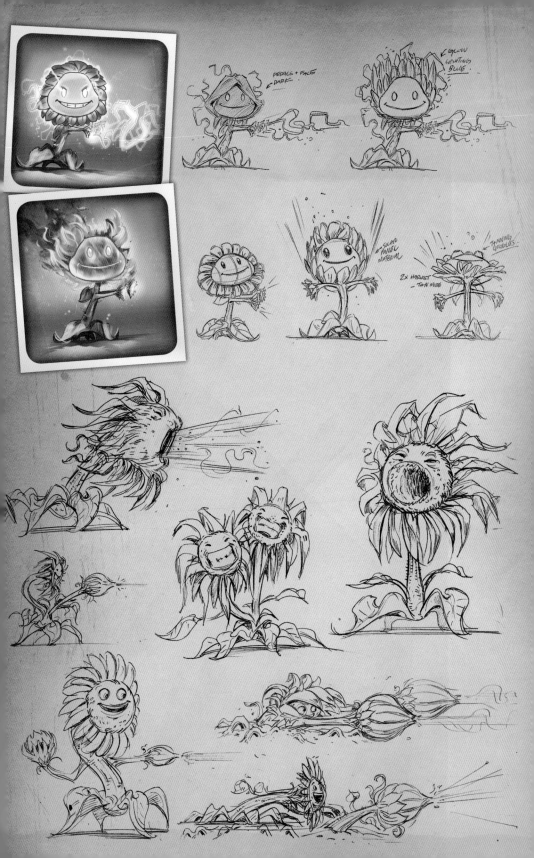

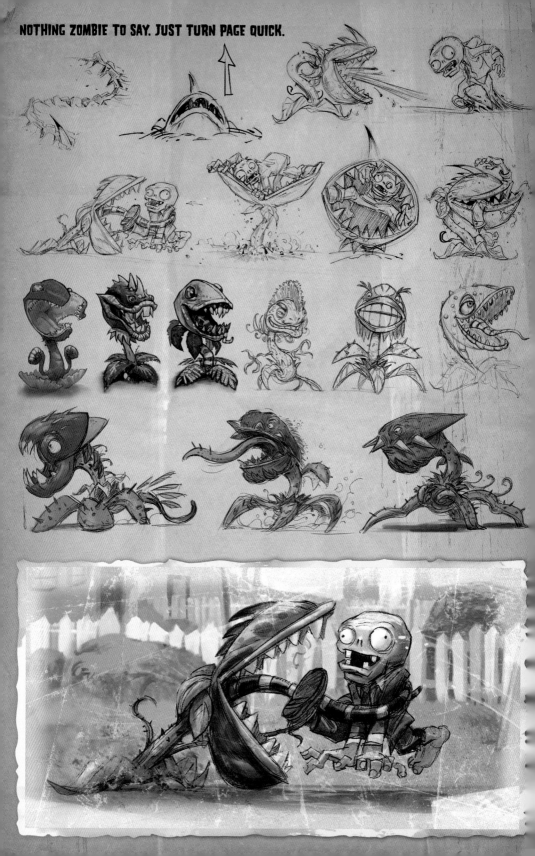

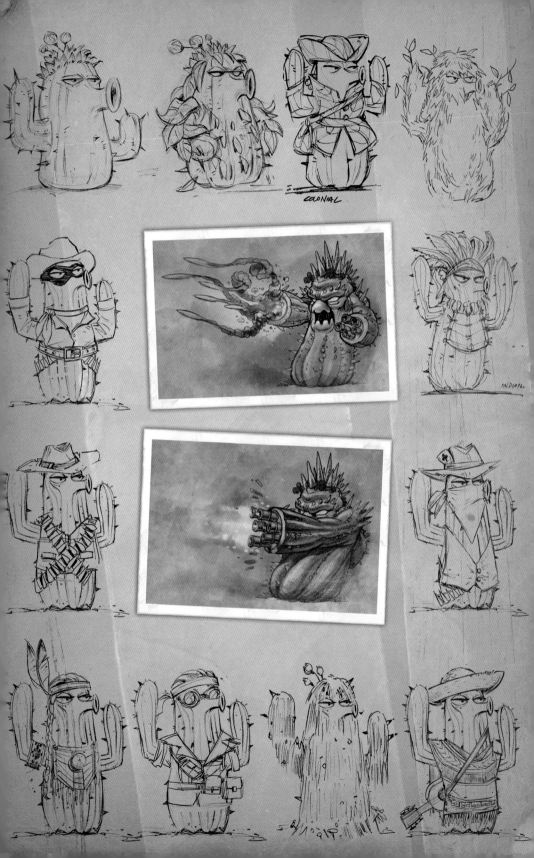

COLONIAL

INDIAN.

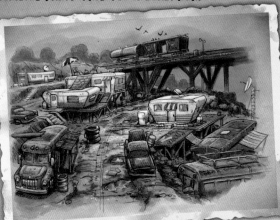

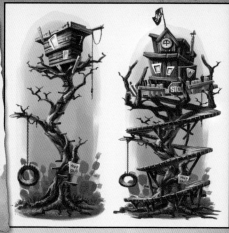

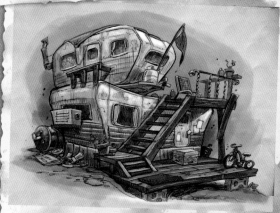

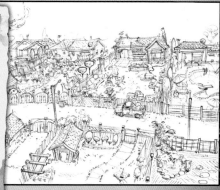

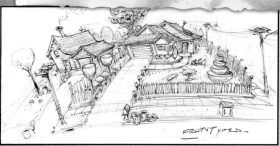

FRONT YARD

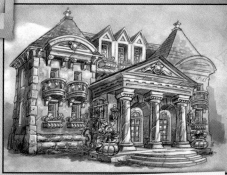

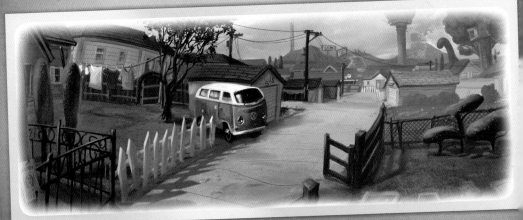

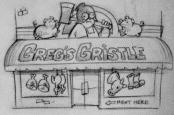

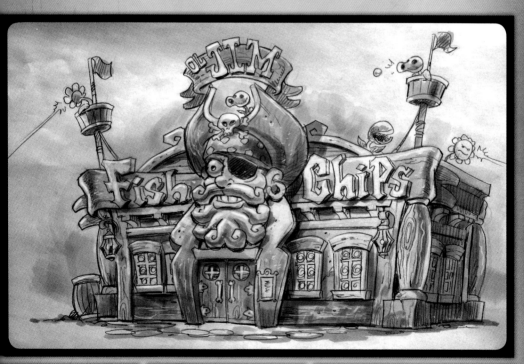

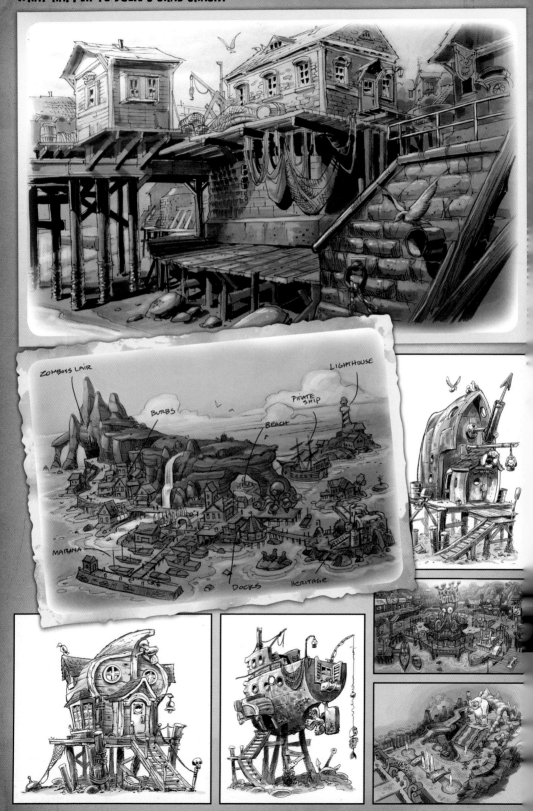

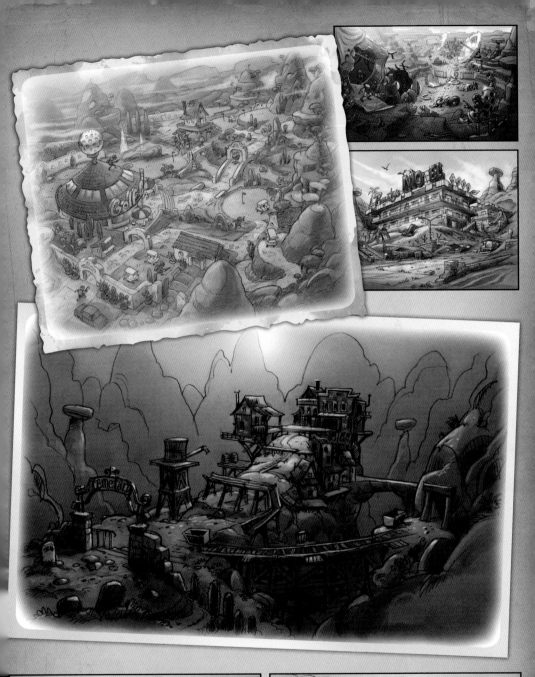

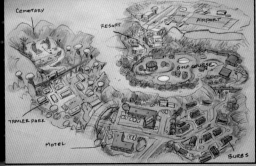

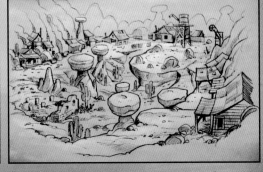

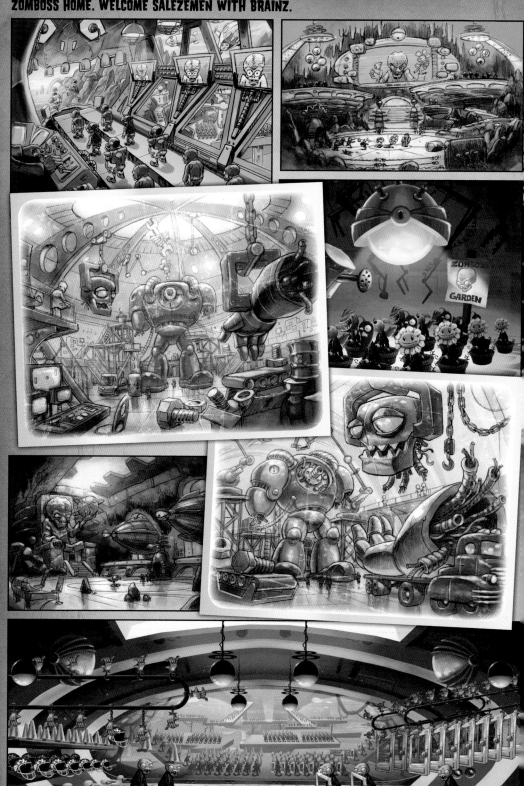

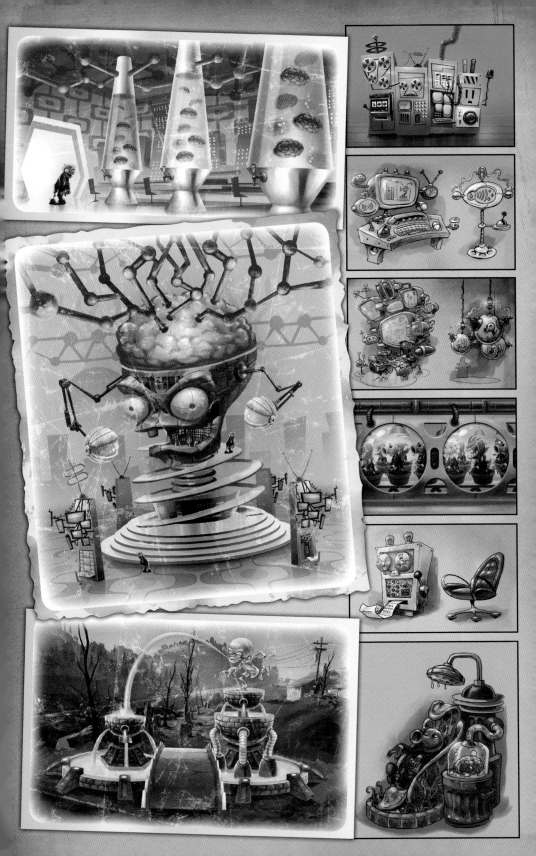

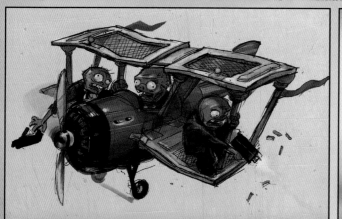
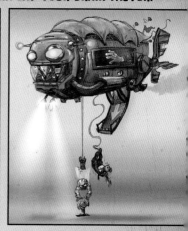
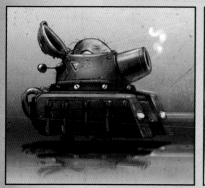
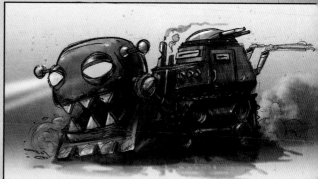
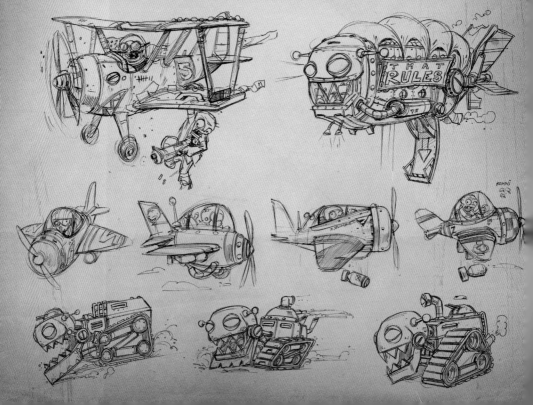

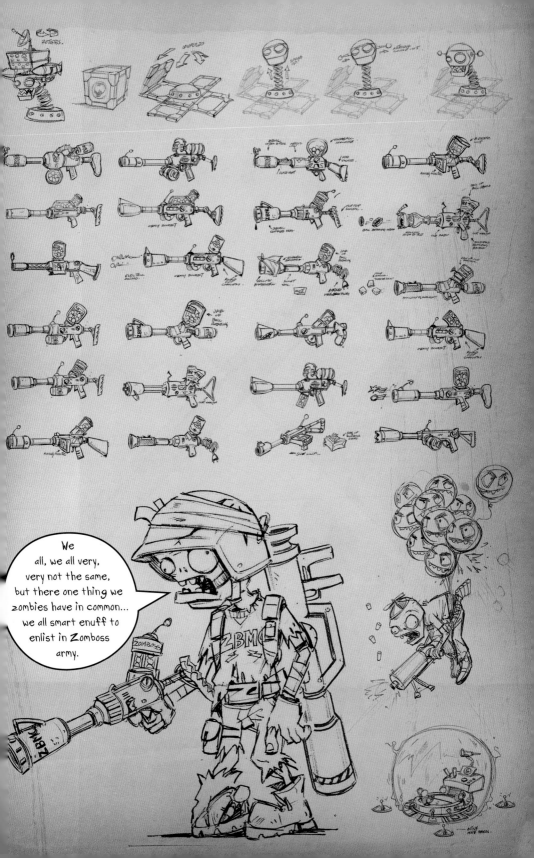

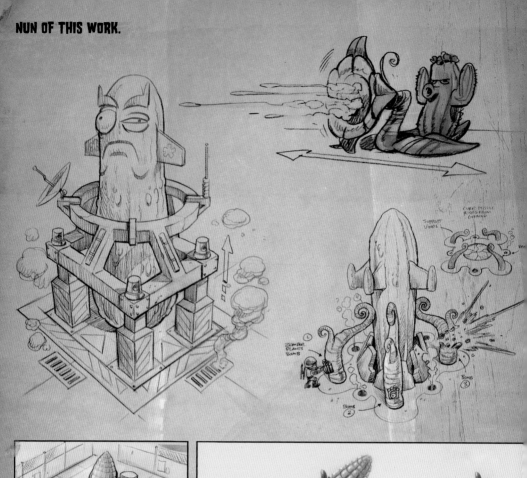

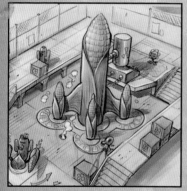

1. PUT COIN IN SLOT — LEVER RELEASES...

TALL-NUT GROWS IN PLACE

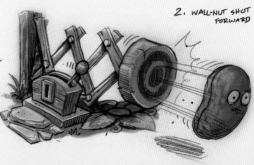

2. WALL-NUT SHOT FORWARD

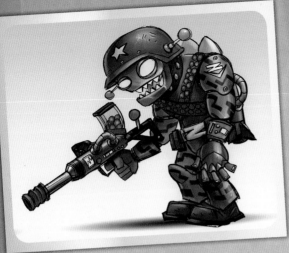

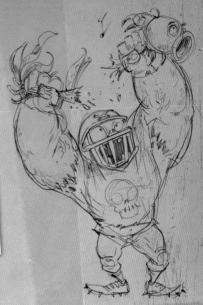

TOTAL VICTORY!

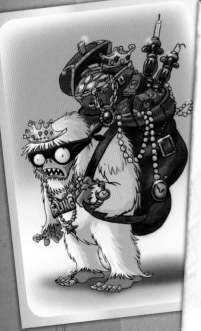

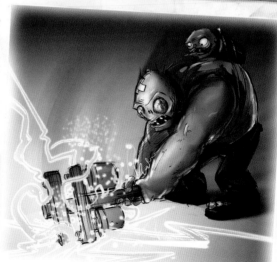

Zombies rule. Look at the size of this zombie. Either one. We gave big one pony and ice cream for tearing this down. He very happy.

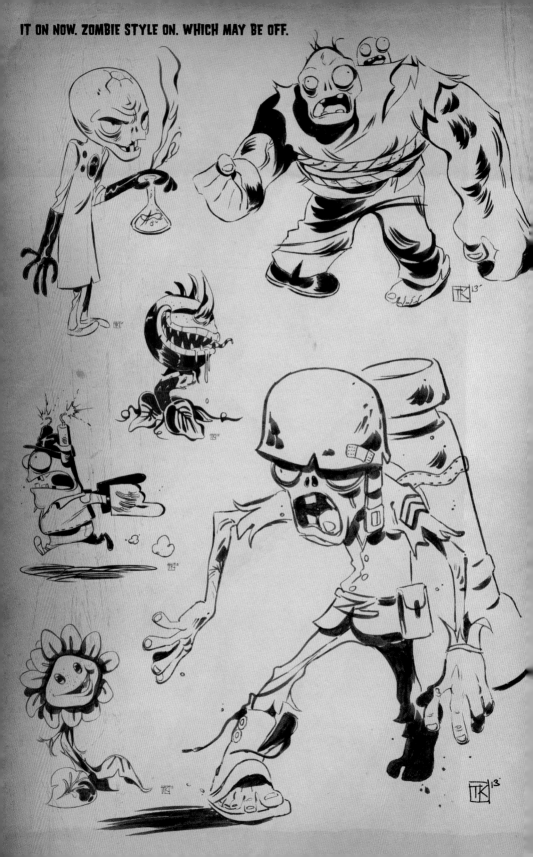

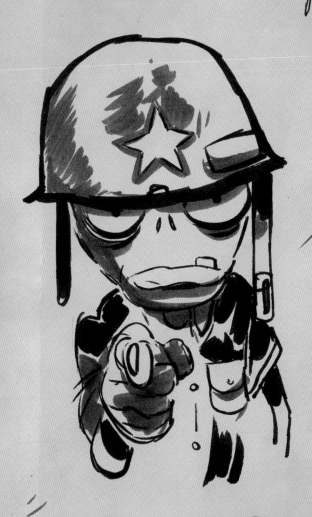

I WANT **YOUR** BRAINS

DEAD FACE

FOREIGN EXCHANGE ZOMBIES

To unsophistimicated eye, zombies are just a big shambling horde of relentless sameness. But for thems what take the time to look closely, it becomes ~~aprp arpap~~ clear that every zombie is a unique and precious snowflake. With legs.

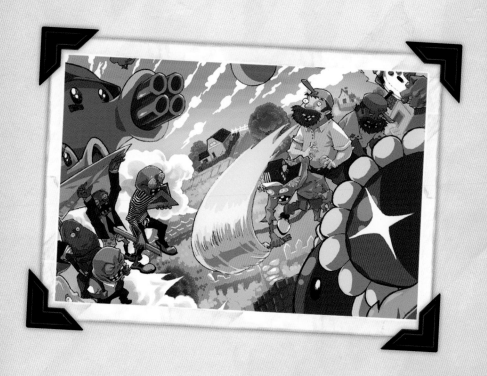

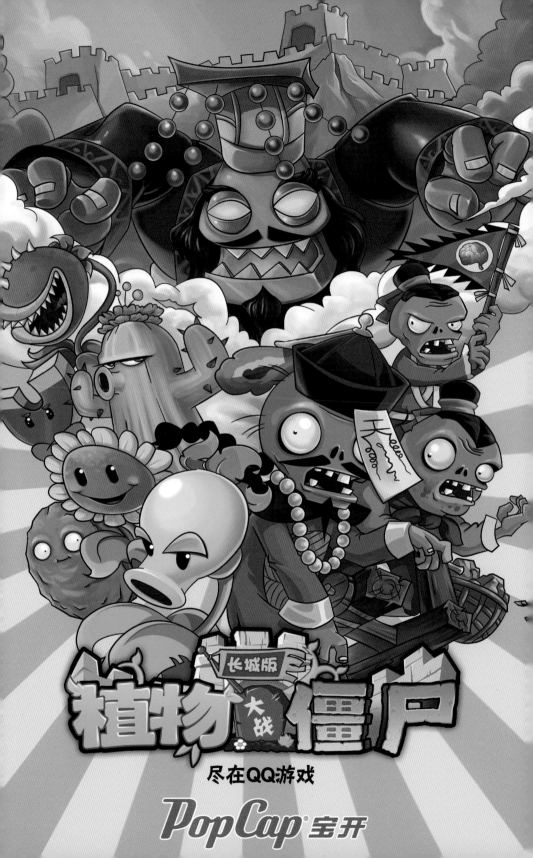

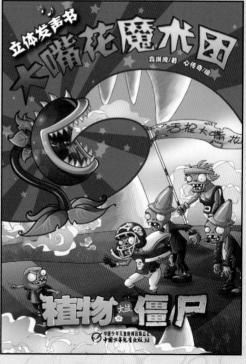

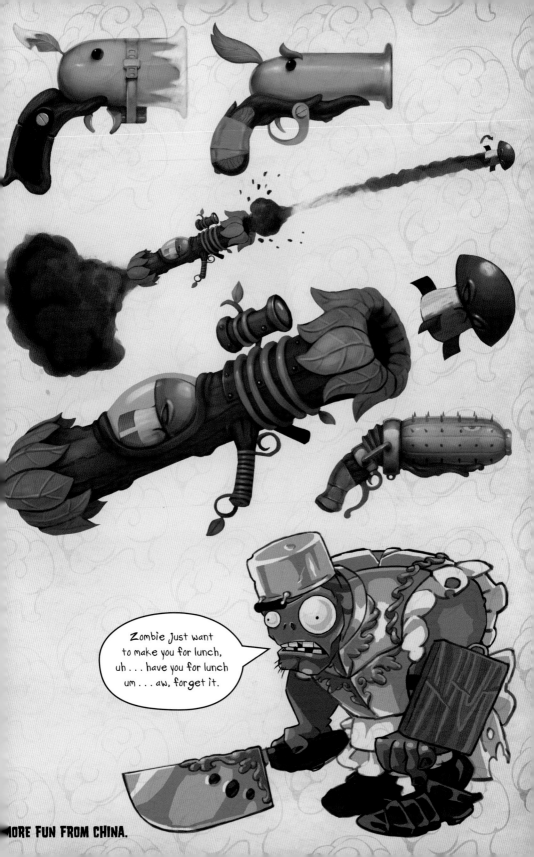

Zombie just want to make you for lunch, uh . . . have you for lunch um . . . aw, forget it.

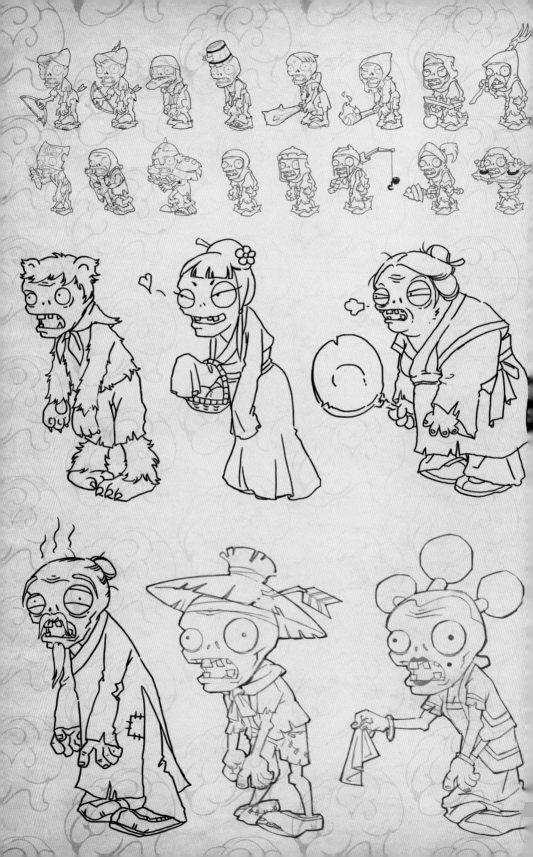

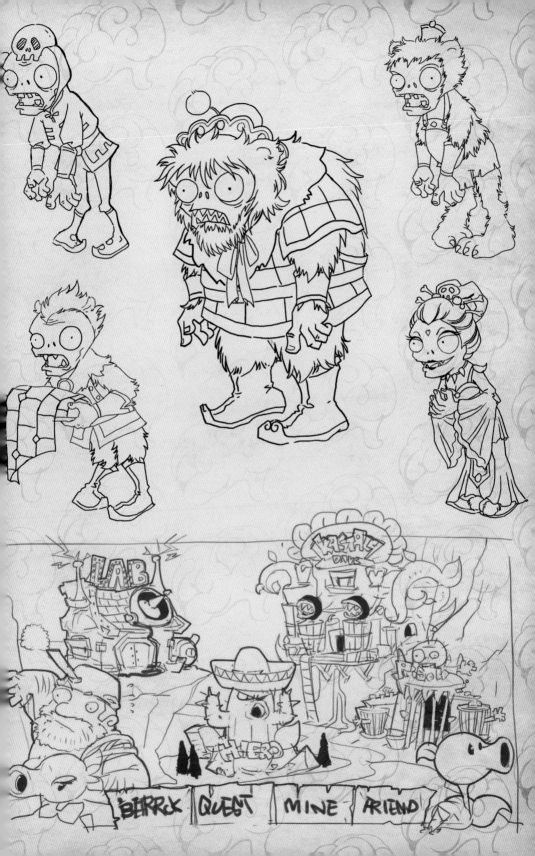

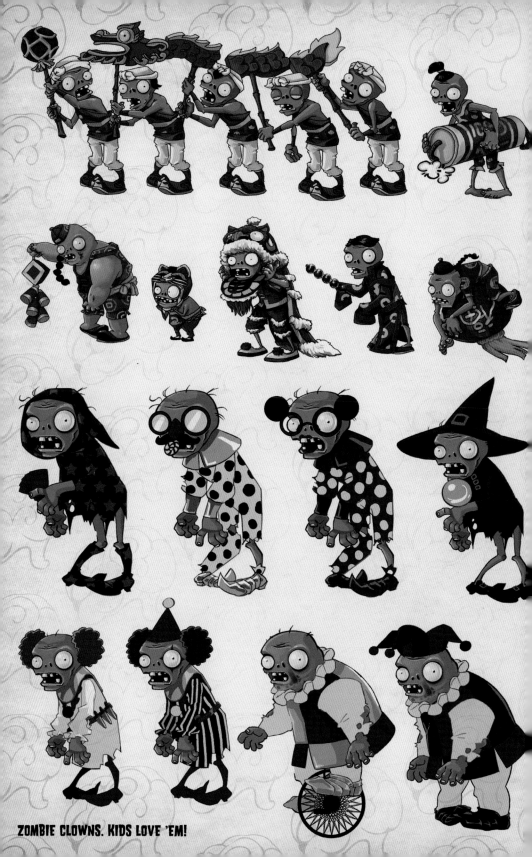

ZOMBIE CLOWNS. KIDS LOVE 'EM!

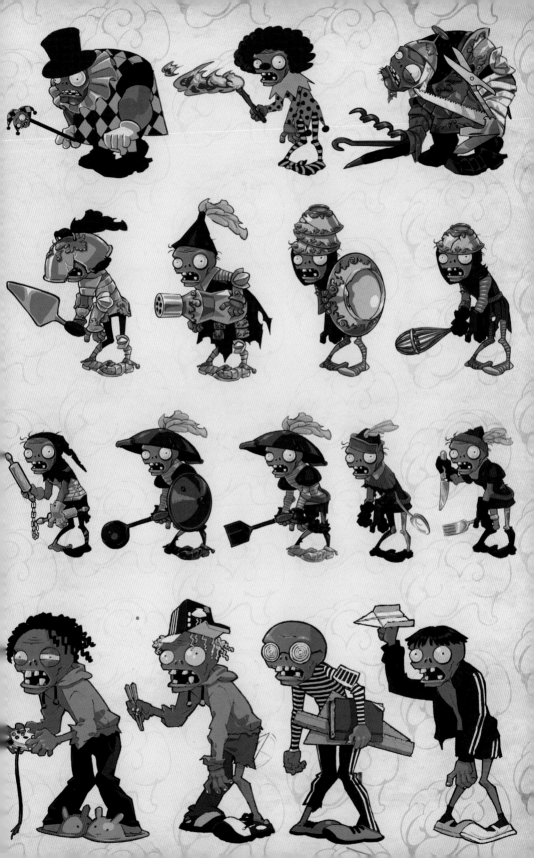

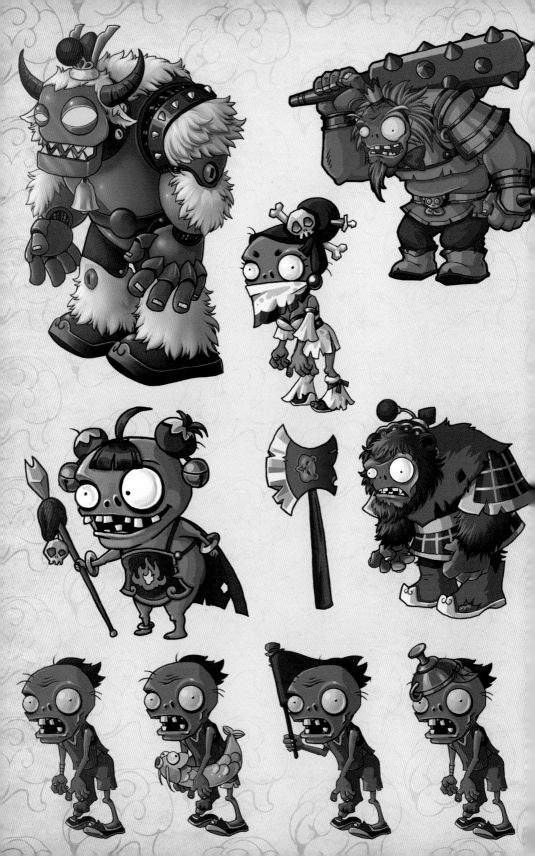

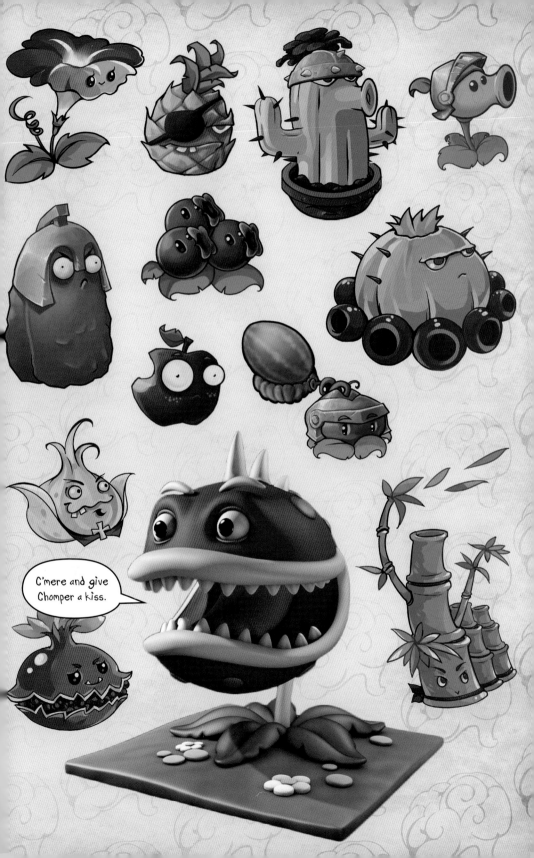

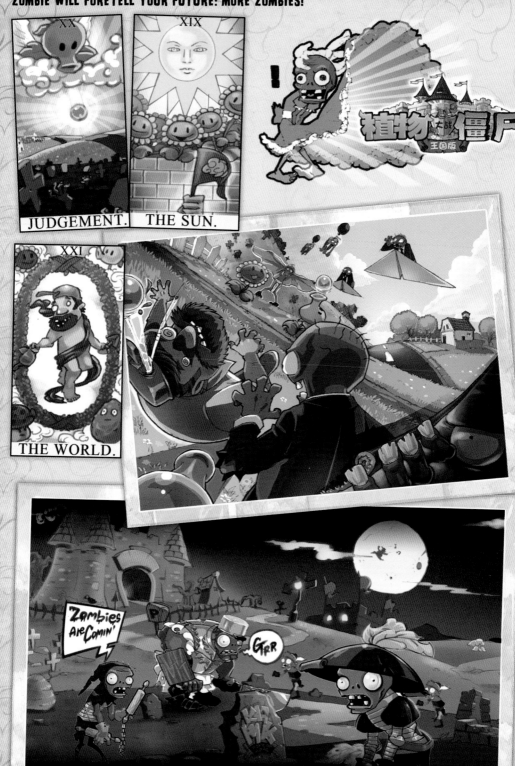

PLANTS VS. ZOMBIES

NOW AND FOREVER

Everybody alwayz ~~thiunk thinkun~~ sure that they
gonna defeet the zombies. Here we are to tell you—
that not happening. Because zombies everywhere
and there too. Maybe even in your cheeseburger.

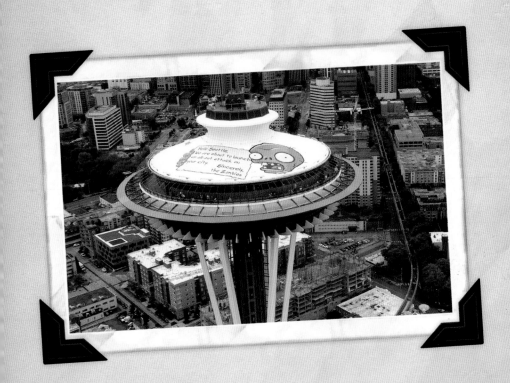

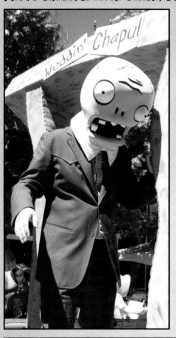
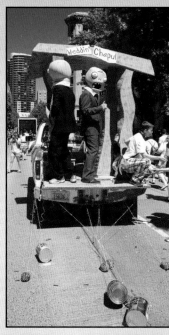

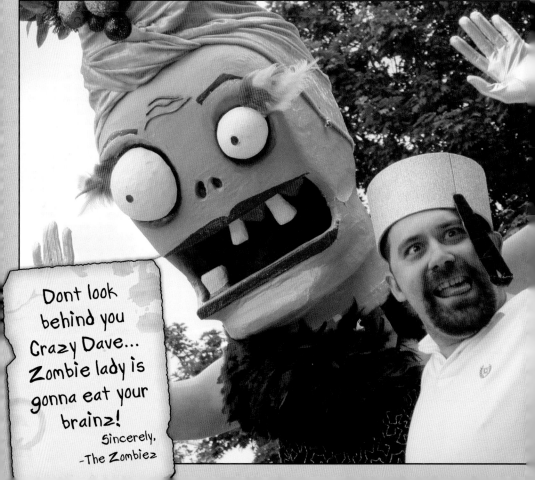

Dont look behind you Crazy Dave... Zombie lady is gonna eat your brainz!
Sincerely,
-The Zombiez

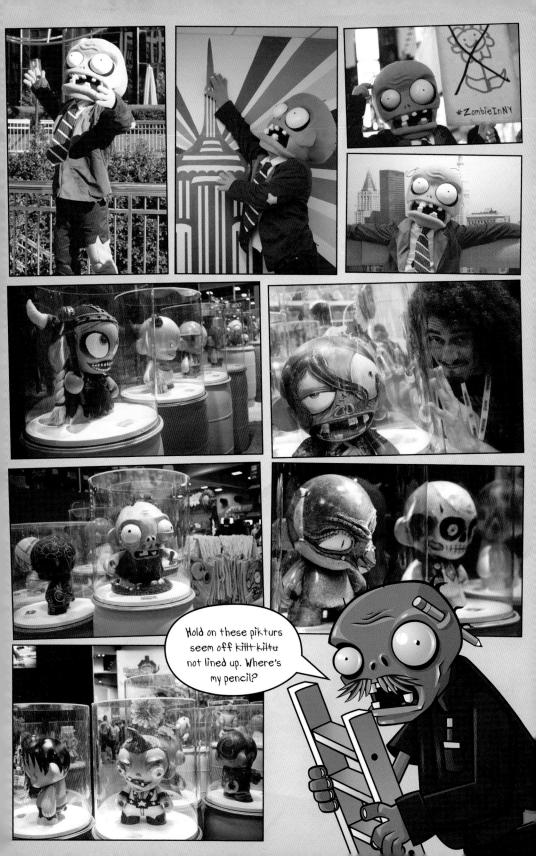

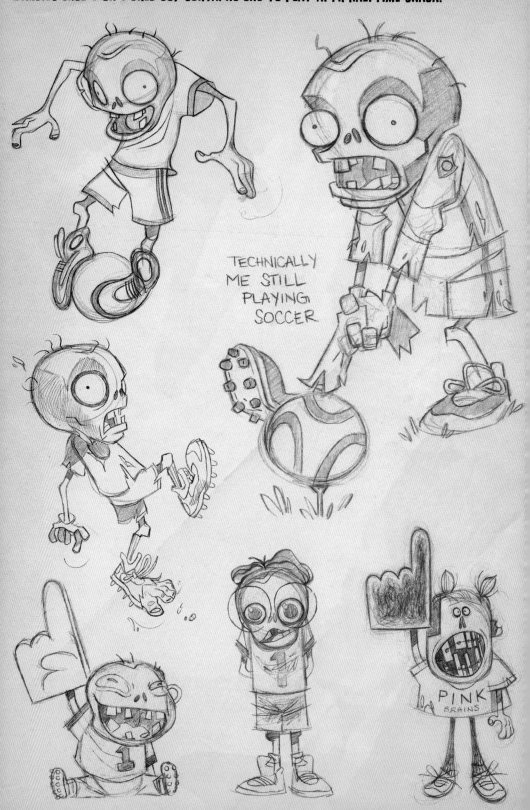

TECHNICALLY
ME STILL
PLAYING
SOCCER

PINK
BRAINS

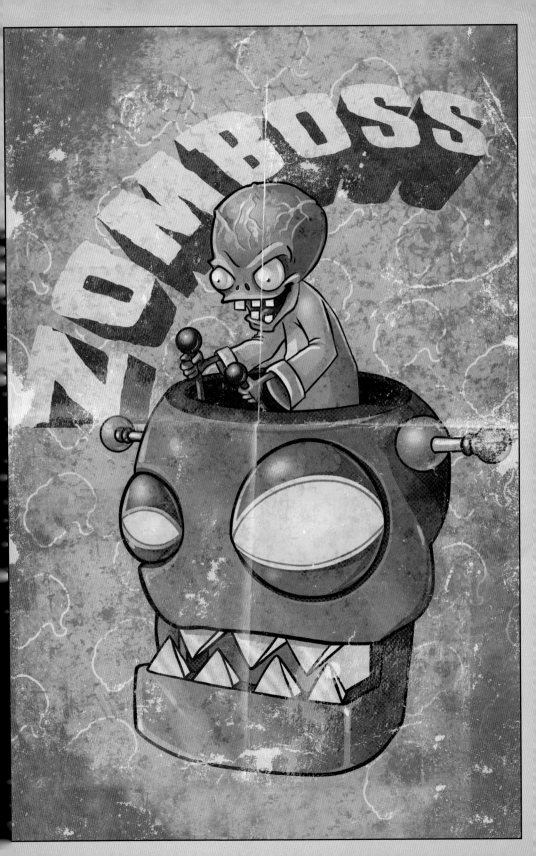

YEH, ZOMBIE WENT HOLLYWOULD. GOT AGENT BIGTIME NAMED LEIGH AND ALL. HAVE WORN FIVETEEN MUSTACHES. "SOLD OUT," SAID YOU? MAYBE YOU NOT JUDGE ZOMBIE UNTIL YOU WALK MILE WITHOUT ZOMBIE'S FOOT.

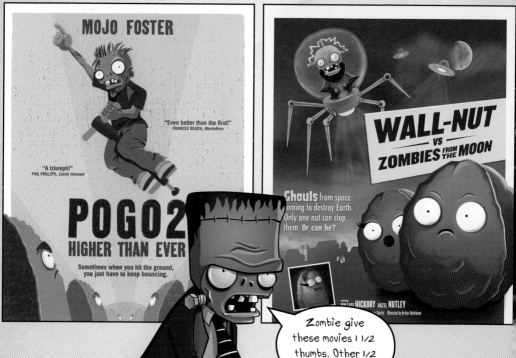

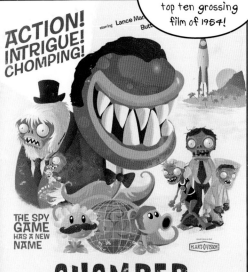

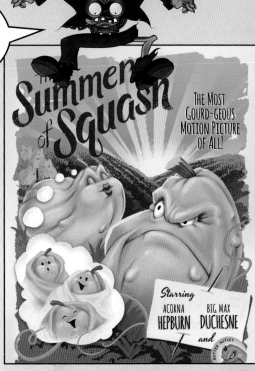

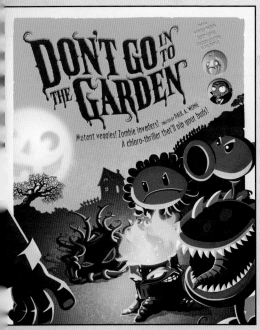

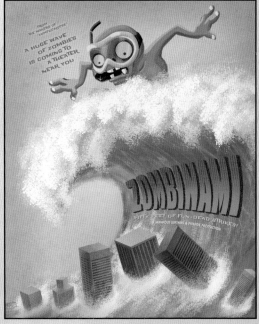

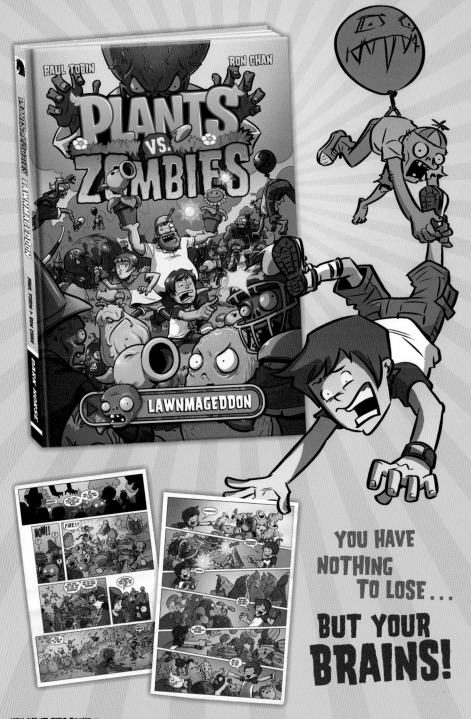

Ron Chan

This art guy drew a comic. We posed for it.

He asked cause he very smart and we very pretty.

Then he went and put a plant on his head. We wont forget.

Where were we? Oh, right. Very good comic but lies to make plants look better.

You should read it before we get to your house.

-The Zombies

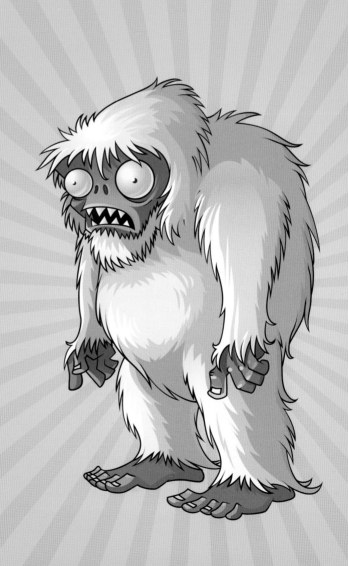